RED SOX LEGENDS

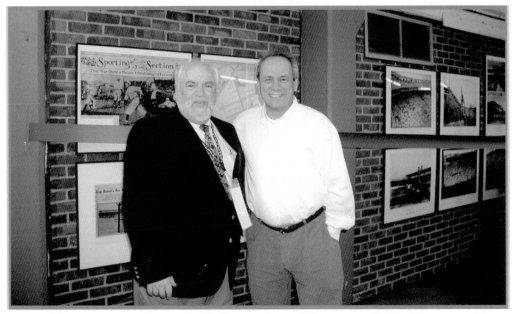

Pictured here are Bernard Margolis (left), president of the Boston Public Library, and Larry Lucchino, president and CEO of the Boston Red Sox.

RED SOX LEGENDS

JENNIFER LATCHFORD AND ROD ORESTE
FOR THE BOSTON PUBLIC LIBRARY
AND THE BOSTON RED SOX

Published by Arcadia Publishing
Charleston SC, Chicago IL, Portsmouth NH, San Francisco CA

Library of Congress control number: 2006938406

For all general information contact Arcadia Publishing at:
Telephone 843-853-2070
Fax 843-853-0044
E-mail sales@arcadiapublishing.com
For customer service and orders:
Toll-Free 1-888-313-2665

Visit us on the Internet at www.arcadiapublishing.com

On the cover: Please see page 40. (Leslie Jones photograph, from the Leslie Jones Collection of the Boston Public Library.)
Cover background: Please see page 20. (From the Sports Collection of the Boston Public Library.)

FOREWORD

This book was borne from a long-term partnership between our two great Boston institutions. The cultural heritage of Boston and the history of the Red Sox are permanently intertwined. The Red Sox have been a significant part of the cultural fabric of the city ever since the franchise first played at the Huntington Avenue Grounds in 1901. The Boston Public Library, in its efforts to preserve Boston's cultural heritage and promote lifelong learning, has an unparalleled collection of historical Red Sox images. By creating the Galleries at Fenway Park, we are presenting these rarely seen images to Red Sox fans visiting Fenway Park. This book is based on one gallery located at the park's Autograph Alley, a display that shows Red Sox legends through the years.

We hope you enjoy this book, and we remind you to bring it with you when you visit the park. We have included pages at the back for the autographs you receive when you meet the legends of Red Sox history on your visits to "America's Most Beloved Ballpark." We also remind you to enjoy reading the greatest collection of books about baseball that you can find. They are all ready and waiting for you, now, at your Boston Public Library. Come visit.

Bernard Margolis, President, Boston Public Library
Larry Lucchino, President/CEO, Boston Red Sox

ACKNOWLEDGMENTS

All original images are owned by the Boston Public Library, as part of its Prints Collections, or the Red Sox Archives, unless otherwise noted. Unless otherwise noted, the photographer is unknown.

Special thanks go to Dick Bresciani, Dr. Charles Steinberg, Jonathan Gilula, Dick Johnson, Alan and Jason Kimenker, Aaron Schmidt, Henry Mahegan, and Nick Milono for their assistance in making this book possible.

INTRODUCTION

All my father ever talked about was Ted Williams, the greatest player to ever play the game. His memories of Williams brought him back to his childhood, the time when he first fell in love with baseball.

As a kid growing up in Somerset, I couldn't help but become a Red Sox fan. The 1967 Red Sox drew me in as a young teenager and made me a Sox fan for life. I went to opening day that year. The Sox played their way into the World Series, and, like most people in New England, I was locked in on them. Watching the Red Sox mount comeback after comeback in 1967 taught me that you can never lose faith. That's the magic of Red Sox baseball.

Every citizen of Red Sox Nation has a unique story about how the team, a game, or a player touched their lives. For my dad, it was Williams. For me, it was Yaz and that 1967 team.

In the pages that follow, you will find photographs taken by Leslie Jones and other Red Sox photographers who captured the moments and players that are part of Red Sox history. Along with the images, you will read personal accounts from players discussing their own Red Sox memories and how the team, the game, and that famous ballpark have shaped their lives. Enjoy the book.

Jerry Remy
October 4, 2006

The Boston Red Stockings were charter members of the National Association of Baseball (later changed to the National League). They were quite successful until the opening of Boston's entry in the competing American League, the Boston Americans. Shown here is the 1900 team, called the Boston Beaneaters. In 1900, this team went 66-72, had a winning percentage under .500, and finished fourth in the league. Many of the players pictured went on to play for the Boston Americans when they were offered better contracts to play in the new league. The Beaneaters (later the Braves) suffered mightily over the ensuing years, until 1914 when they stunned the league by going from last place to first place in less than two months and winning the World Series. Pictured from left to right are the following: (first row) unidentified, Billy Hamilton (outfielder), Kid Nichols (pitcher), Frank Selee (manager) with dog, Herman Long (shortstop), Fred Tenney (first baseman), and Jimmy Collins (third baseman); (second row) unidentified, Buck Freeman, unidentified, Bill Dinneen (pitcher), Ted Lewis (pitcher), and unidentified; (third row) Bobby Lowe (second baseman), unidentified, Chick Stahl (outfielder), Hugh Duffy (outfielder), and unidentified.

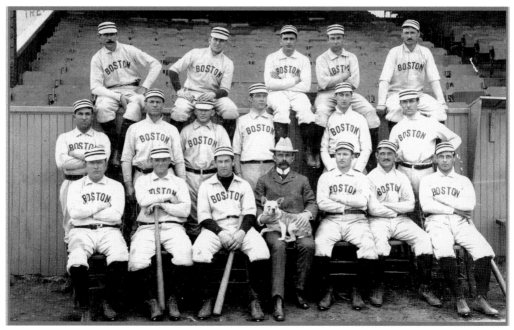

Elmer Chickering photograph, the McGreevey Collection of the Boston Public Library, 1900

Boston was one of the original eight teams that began the American League in 1901. The team won the first World Series in 1903 and was known as the Boston Americans. The legends of that team include Cy Young, Jimmy Collins, and Chick Stahl (the last two stolen from the local National League team, the Boston Beaneaters). Young, with a career that spanned two decades and produced 511 wins, is generally regarded as one of the finest pitchers in the history of the game. Stahl contributed to the 1903 World Series victory by hitting three triples. The Boston Americans played at the old Huntington Avenue Grounds, on the current campus of Northeastern University, prior to their move to Fenway Park in 1912. In 1903, Boston was already crazy for baseball, and the Huntington Avenue Grounds were often packed to capacity. It was a more permissive environment than today. In fact, prior to the third game of the 1903 World Series, fans were allowed to walk on the field. This team photograph ran in a local newspaper after Boston won the 1903 World Series.

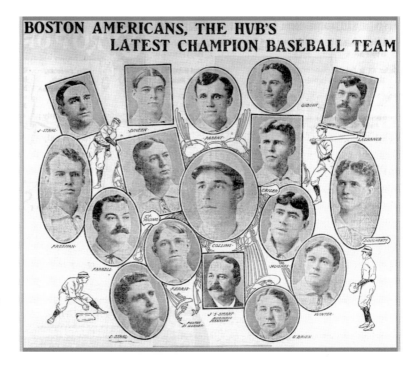

Published by the Boston Globe, from the Boston Newspaper Archive of the Boston Public Library, September 1903

Michael McGreevey, often known as "'Nuf Ced" McGreevey because of his way of ending arguments, was the penultimate Boston baseball fan. Not only was he the head of the Royal Rooters, but he was also the owner of a local tavern aptly named Third Base because it was the last place one stopped before one went home. His tavern was decorated with baseball memorabilia of Boston's hometown heroes, much of which now resides in the collections of the Boston Public Library. The Royal Rooters showed their devotion by cheering, chanting, and sometimes razzing the opposing team. In fact, it was this group that introduced the local crowd to "Tessie," a hit song from a Broadway musical. The song was meant to taunt and tease the opposing team but became more of a rallying cry as the years wore on. Recently the song inspired a new version recorded by the Dropkick Murphys that is often played at Fenway Park. 'Nuf Ced (far right) is shown here with, from left to right, newly retired Cy Young (who was the ERA champion in 1901, pitched the only perfect game in Red Sox history on May 5, 1904, and pitched a no-hitter in June 1908), player-manager Jake Stahl (who was the 1910 home run champion with 10 home runs and had 105 wins in the 1912 season), and catcher Bill Carrigan (who had 101 wins in the 1915 season as the manager) in Hot Springs, Arkansas, during spring training.

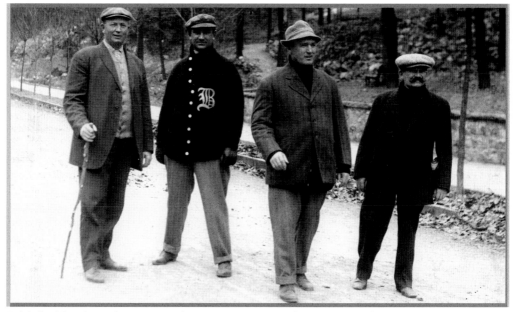

Published by the Arlington Studios, Hot Springs, Arkansas, from the McGreevey Collection of the Boston Public Library, *c.* 1910

In their first season in the newly built Fenway Park, the Red Sox took home the world championship for the second time since the American League's inception in 1901. Their new home was recognized for its innovations, including the net installed behind the catcher to prevent errant balls from entering the stands. The park itself opened in April 1912 and garnered rave reviews, as did the team. Many of the legends of this team—Bill Carrigan, Harry Hooper, Larry Gardner, Tris Speaker, "Smokey Joe" Wood, Jimmy Collins, Jake Stahl—are household names to Red Sox fans. One player depicted is Bill Carrigan, who was appropriately nicknamed "Rough." The rugged and tough catcher had a bulldog's personality and an uncompromising attitude that earned him immediate respect on the team. Carrigan caught for the Red Sox for 10 seasons, from 1906 to 1916, and was a player-manager for the final three seasons. After finishing second in 1914, Carrigan managed to lead his team to two consecutive World Series championships in 1915 and 1916. After his second World Series title in as many years and at the pinnacle of his baseball career, the 33-year-old Carrigan decided to call it quits. He is still the only Red Sox manager in history to ever win back-to-back World Series titles. This postcard shows the 1912 team with the names of the players added.

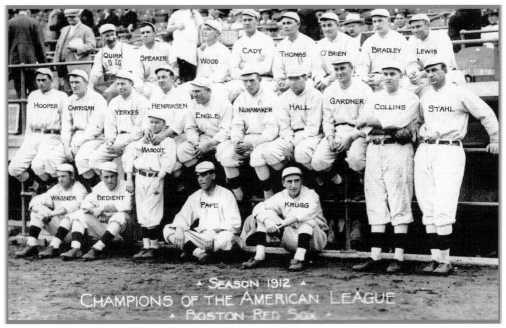

QUIRK
RED SOX
SPEAKER
WOOD
CADY
THOMAS
O'BRIEN
BRADLEY
LEWIS

HOOPER
CARRIGAN
YERKES
HENRIKSEN
ENGLE
NUNAMAKER
HALL
GARDNER
COLLINS
STAHL

MASCOT

WAGNER
BEDIENT
PAPE
KRUGG

★ SEASON 1912 ★
CHAMPIONS OF THE AMERICAN LEAGUE
★ BOSTON RED SOX ★

The Photo Art Shop, from the Sports Collection of the Boston Public Library, 1912

In 1912, Tris Speaker was the center fielder. Duffy Lewis, the left fielder, called him "the King of the Outfield" as he would always call out "you take it" or "I got it" on fly balls. Speaker ranks among Red Sox's all-time fielding leaders for outfield assists and double plays. His extraordinary speed not only made him a threat on the base paths but also allowed him to play a very shallow center field in order to rob opposing hitters of base hits. Speaker was also blessed with a rifle arm and holds the record for American League runners thrown out (35) in a season, which he accomplished twice, in 1909 and 1912. Left fielder Lewis burst onto the baseball scene in 1910 and became an instant star as he hit .283 and led the Red Sox with 29 doubles in his rookie year. Throughout his entire Red Sox career, his offensive production was always consistent, but it was his spectacular defense that made him famous. When Fenway Park was built in 1912 with its unusual 25-foot-high left field fence, it was supported by a 10-foot-high dirt embankment in left field. The hill sloped at a 45-degree angle and caused havoc for many opposing outfielders attempting to field a long fly ball. But Lewis was so adept at climbing the hill to catch flies that it became known as "Duffy's Cliff." On a hard-hit fly ball, Lewis would scamper up the hill, spot the ball, and then decide whether to go right, left, or run back down for the catch. Relay throws from the slope often sent him tumbling down to the bottom. "They made a mountain goat out of me," Lewis once said. Harry Hooper, Tris Speaker, and Duffy Lewis (pictured from left to right) comprised one of the greatest all-around outfield trios and were known as the "Million Dollar Outfield." They are shown here at an old-timer's game in 1939.

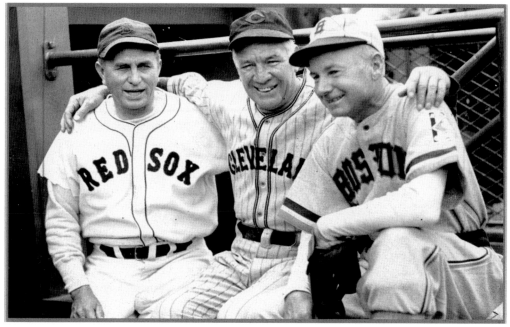

From the Herald-Traveler Photo Collection of the Boston Public Library, *c.* 1939

In 1912, right-hander Smokey Joe Wood was dominant. Wood went a remarkable 34-5 that season. Wood had a rival, however, in Washington Senators star Walter Johnson. Both had strikingly similar seasons. Each had a 16-game winning streak during the season. Johnson's streak started on July 3, and Wood's began only days later on July 8. When the Washington Senators came to Fenway Park in September 1912, they challenged Red Sox manager Jake Stahl to start Joe Wood against the great Walter Johnson. This required Wood to pitch one day earlier than planned, but Stahl jumped at the challenge and obliged. On September 6, 1912, Joe Wood pitched against Walter Johnson. If Joe Wood won, he would hold title to the longest winning streak in 1912. Fans streamed into Fenway Park to see the classic pitching duel. Wood allowed only six hits and stuck out nine. Johnson gave up five hits and struck out five. When the smoke cleared, only one run had been scored—Tris Speaker scored on a Duffy Lewis double for a Red Sox win. Later when someone asked Johnson if he could throw harder than Wood, the flame-throwing hall of famer said, "Listen, my friend, there's no man alive who can throw harder than Smokey Joe Wood." This photograph depicts pitching greats from earlier years together again at an old-timer's game in 1939. Seen here are, from left to right, Joe Wood (ERA champion in 1915 and pitched a no-hitter on July 29, 1911), Cy Young , Lefty Grove (ERA champion in 1936, 1938, and 1939), and Walter Johnson.

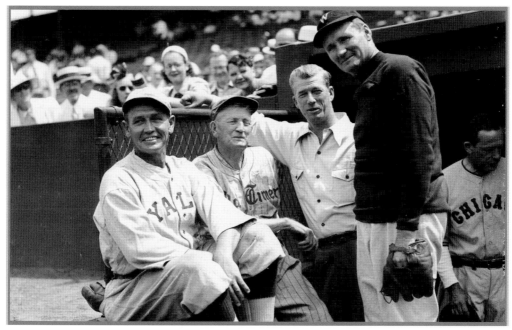

Leslie Jones photograph, from the Leslie Jones Collection of the Boston Public Library, July 1939

The year 1915 was Babe Ruth's rookie year. It is ironic that one of the greatest pitching acquisitions for the Red Sox later became one of the greatest sluggers of all time, the "Sultan of Swat" for the New York Yankees. He was first signed as a pitcher with the minor-league Baltimore Orioles, who were regarded as one of the greatest minor-league teams ever assembled at the time. Unfortunately the Federal League was floundering, and Baltimore owner Jack Dunn saw the writing on the wall. He sought to sell off his most talented players as he felt the Federal League was heading to its demise. Red Sox owner Joe Lannin jumped at Dunn's offer and bought three prospects: catcher Ben Egan, right-handed pitcher Ernie Shore, and left-handed pitcher George Herman Ruth, better known as Babe. In 1915, his first full season pitching for the Red Sox, he went 18-6 to lead the staff with a .750 wining percentage. In 1916, Ruth led the American League with a 1.75 ERA and went 23-12. His greatest pitching accomplishment was his record 29.2 consecutive scoreless innings in World Series play. There is no question that Ruth was one of the most valuable pitchers for the Red Sox in their 1915, 1916, and 1918 World Series championships. This 1915 team photograph shows the young Babe Ruth with teammates, including Ernie Shore.

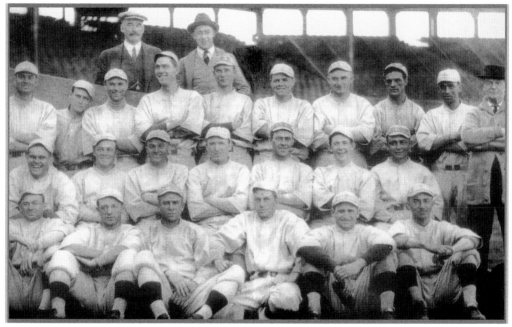

From the Sports Collection of the Boston Public Library, 1915

Harry Hooper played right field in the "Million Dollar Outfield" with Tris Speaker and Duffy Lewis. He was a dangerous leadoff hitter, but his defense was arguably his greatest weapon. Along with his 2,757 putouts, Hooper recorded 260 outfield assists, the most in Red Sox history. Hooper played for four Red Sox world champions: 1912, 1915, 1916, and 1918. One of his greatest defensive plays came during the 1912 World Series. In the final, deciding game, the Red Sox and the New York Giants entered the ninth inning deadlocked at 1-1. The Giants' Larry Doyle was at bat and smashed a hard line drive to right. Hooper sprinted back toward the stands as the ball rocketed toward the low right field fence. When Hooper had no more room to run, he made a diving, desperate leap that sent him crashing into the fans. Before he cleared the wall, Hooper stretched out and caught Doyle's home run ball to save the game. There has been much controversy over the years as to whether Hooper was still in the playing field when he made the catch. None of it matters to Red Sox fans. The catch paved the way to a 3-2 Red Sox win in the 10th inning. The Red Sox were World Series champions, and Hooper was an instant hero in Boston. Hooper is shown here as a member of the 1915 Red Sox.

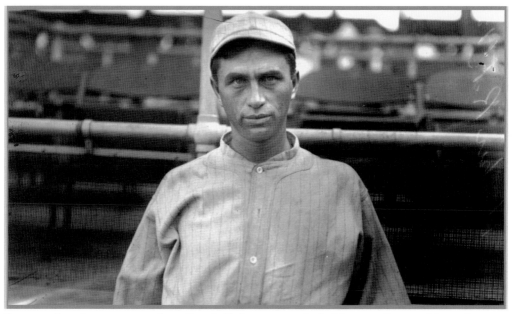

Reprinted with permission from Baseball Antiquities Ltd., Newton Center, Massachusetts, copyright 1989–2007, www.baseballantiquities.com, 1915

Larry Gardner joined the Boston Red Sox in 1908 and became a starter at second base in 1910. In 1912, as a third baseman, he batted .285 and led the Red Sox with 18 triples as the team won its second World Series. Gardner became a hero in Boston during the 1912 season. With the World Series tied at three games apiece, and the seventh game tied 1-1 after nine innings of play, the Giants took a one-run lead in the 10th, and the Sox were down to their final three outs. An error, a sacrifice fly, a single, and an intentional walk loaded the bases to set up for a force play at home. Gardner stepped to the plate and with a simple sacrifice fly, he sent the Fenway Faithful home celebrating when he sent the final run across the plate to win the 1912 World Series. From 1908 through 1917, Gardner played for the Boston Red Sox. In his 17-season career, Gardner posted a .289 batting average with 27 home runs and 929 RBIs in 1,922 games. Gardner played on three championship Red Sox teams, 1912, 1915, and 1916. He is shown here as part of the 1915 team photographed at Fenway Park.

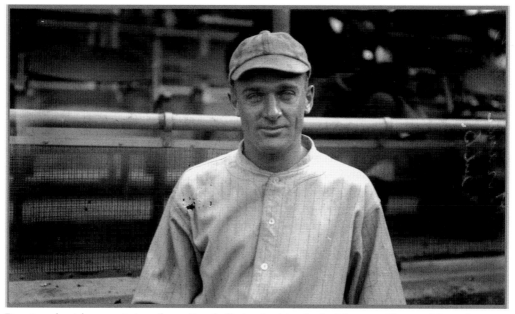

Reprinted with permission from Baseball Antiquities Ltd., Newton Center, Massachusetts, copyright 1989–2007, www.baseballantiquities.com, 1915

Ernie Shore will forever be linked to Babe Ruth. They both pitched in Ernie Shore's legendary perfect game, the only perfect game thrown by a Red Sox pitcher at Fenway Park. On June 23, 1917, Babe Ruth started the game at Fenway Park against the Washington Senators. The first Senators batter, Eddie Foster, walked on a ball four call by home plate umpire Brick Owens. Ruth fiercely disagreed with the call, and after a shouting match, the umpire tossed Ruth from the game. Ruth responded by punching him in the neck before he was led off the field. The Red Sox needed a pitcher, and manager Jack Barry called on Shore, fresh off his own suspension from a skirmish with the White Sox in Chicago. On Shore's first pitch, Foster was caught stealing. Shore retired the side on his next two pitches. Shore stayed on the mound and recorded 24 more consecutive outs for the perfect game. Through nine innings pitched, Shore struck out just two batters. According to George Sullivan's *The Picture History of the Boston Red Sox*, Shore later said, "I don't think I could have worked easier if I'd been sitting in a rocking chair. I don't believe I threw 75 pitches that whole game, if I threw that many. They just kept hitting it right at somebody." This cover from *Baseball Magazine* shows famous Red Sox players from the 1916 season: Ruth, Everett Scott, Shore, Larry Gardner, Bill Carrigan, and Harry Hooper. It would be the season they won their fourth world championship.

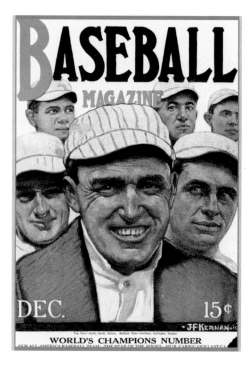

J. F. Kernan illustration, from the Baseball Magazine Collection of the Boston Public Library, 1916

[Babe] Ruth was born to parents unknown. He was raised by a saloon keeper in Baltimore by the name of Ruth, and he took that man's name. Later he went to a group of Catholic clergymen, and he went to school there and they had some influence on him. As a consequence of his boyhood—I'm sure it had some bearing on it—Ruth would always stop and sign autographs coming out of Yankee Stadium for kids. Kids would walk all over his white shoes—he was an immaculate dresser—and his cream-colored pants and he'd stand there and sign autographs for a long time after the game was over. Also, he would go and visit kids in hospitals, but he would never take a photographer and he would never take newspaper writers with him, and he didn't want any notice or attention paid to that. He was a kindly fella and generous too.

—Billy Werber

This picture from *Baseball Magazine* shows Red Sox players, from left to right, Michael Joseph McNally, Dick Hobitzell, and Babe Ruth hunting at the Maynard Hunting Camp in New Hampshire.

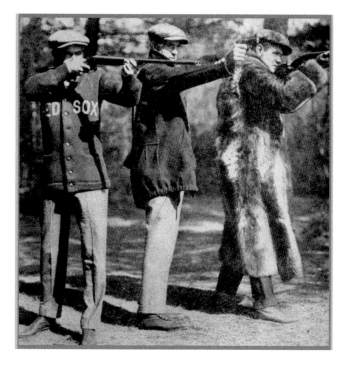

From the Baseball Magazine
Collection of the Boston
Public Library, 1916

In 1923, Howard Ehmke almost pitched two consecutive no-hit games. His first no-hitter was saved by a stroke of luck, and then, four days later, his bid for a second consecutive no-hitter was lost due to a controversial call. On September 7 in Philadelphia, Ehmke had not given up any hits through the sixth inning against the Athletics. However, opposing pitcher Slim Harris set out to help his own cause and roped a line drive off the center field wall. Harris hustled to second base for an apparent double, but to his misfortune and Ehmke's good luck, he was called out as he failed to touch first base when he made the turn. In the eighth inning, Lady Luck once again struck Ehmke when a fumbled line drive, originally ruled a hit, was later changed to an error by the game's official scorer. As a result, the no-hitter was preserved. Four days later, Ehmke took the mound against the Yankees in Yankee Stadium. On the heels of his pitching gem in Philly, the lanky right-hander could have become the first pitcher to ever throw back-to-back no-hitters. However, when the third baseman failed to field a ball cleanly on the game's first New York hitter, the official scorer ruled it a hit instead of an error, and thus his bid for a second no-hit game was lost. Regardless, his pitching of a single hit in two consecutive games is a Red Sox record.

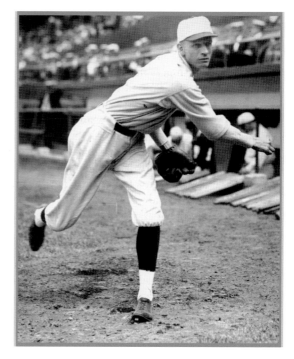

Alfred Brust photograph, from the
Herald-Traveler Photo Collection of the
Boston Public Library, July 9, 1928

Rick Ferrell [used to] massage his forehead. He had two spots on either side of his forehead that were devoid of hair. He felt that by rubbing his scalp, he would grow hair there. So, in spring training of the next year, he received a letter from a guy by the name of Peterson, only it wasn't Peterson, it was me. So "Peterson" wrote Rick Ferrell a letter that he had majored in chemistry at Duke University and gotten a degree and gone into barbershop work and that he had a guaranteed recipe to grow hair on his forehead and it would cost him $500 if he wanted to take the recipe and follow it. Rick showed the letter to me in spring training and said, "Do you know this fella Peterson?" And I said, "Yes, he's a graduate of Duke University and a very sharp fella, and if he says he can grow hair on your head, he can grow hair on your head!" So Rick was about to write him out a check, but "Peterson" backed out of the deal because he felt that they might take away his license if they found out about it. They were great players, great runners, great brothers.

—Billy Werber

Rick Ferrell had a career .281 batting average, 28 home runs, and 734 RBIs. In 1,884 games played, he achieved an impressive .378 career on-base percentage and was an all-star seven times (1933–1938, 1944). His brother Wes is considered one of the best-hitting pitchers in baseball history, setting several major-league records for hitting by a pitcher; he also hit more career home runs, 38 in 548 games. Rick (left) is shown here with his brother Wes in the Red Sox dugout before a game at Fenway Park.

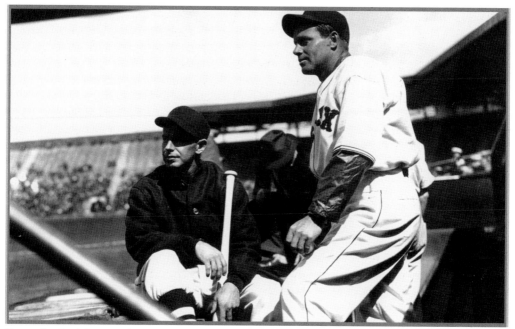

From the Red Sox Archives, *c.* 1934

In the winter of 1935, [Eddie] Collins had taken an option to buy George Myatt, who was a shortstop at that time, and me, as a second base/shortstop combination. And he was supposed to come out in the summer of 1936 to decide whether he was going to take one of us or both of us or what. And it was on that trip that he saw Ted Williams taking batting practice, and Ted might of played in one game, he wasn't playing regular at that time. And he liked his swing so much that he went to the owner of the ball club, Bill Lane, asked if the Red Sox could buy his contract, and Lane said he didn't know enough about the kid and they were going to wait awhile on that. Then Collins had the foresight to say, well, can the Red Sox have the first chance to buy his contract when he was ready, and they shook hands on it and that's how that came about.

—Bobby Doerr

Eddie Collins (center) is shown here with Joe Cronin (left) and Jimmie Foxx. He played over 25 years of major-league ball before he served as the general manager of the Red Sox for 15 years.

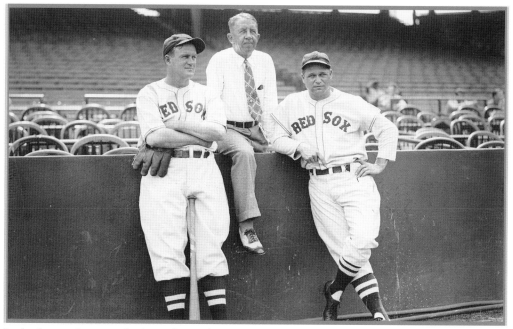

Leslie Jones photograph, from the Leslie Jones Collection of the Boston Public Library, 1937

On July 25, 1941, 41-year-old pitcher Lefty Grove took the mound against the Cleveland Indians in pursuit of the coveted baseball milestone, his 300th victory. Grove was playing in his 17th major-league season, his eighth in a Red Sox uniform. The 300-victory mark was an even more elite class than it is today, as only five pitchers had accomplished the feat before 1941: Cy Young, Walter Johnson, Christy Mathewson, Grover Alexander, and Eddie Plank. It was Ladies Day at Fenway Park as Grove took the mound. The 90-degree temperature did not help his goal as Grove struggled through all nine innings, giving up 12 hits and 6 runs. At one point the Sox were down 4-0 and trailed 6-4 as they headed into the bottom of the eighth inning. But the Red Sox offense, led by Grove's longtime teammate Jimmie Foxx, kept the game close and finished the Indians off to give the southpaw a rare 300 career wins and secure his place among baseball's greats. The Red Sox won the game 10-6. Grove would later declare, "It was the toughest game I ever sweated through." It took 20 years for baseball to see another pitcher reach 300 wins. Warren Spahn became the next 300-game winner in 1961. Grove was the ERA champion in 1936, 1938, and 1939. Grove is pictured here posed for the back inside cover of *Baseball Magazine*.

From the Baseball Magazine Collection of the
Boston Public Library, 1938

I have a funny story about [Jimmie] Foxx. I used to get on Jimmie's case about hitting a ball off the Green Monster and pulling up safe at first base. Now when I hit a ball off that Green Monster, I slid into second and normally I was safe. So I got on him, I said, "Jimmie, you could help the ball club a great deal if you'd run hard the whole way. You could get doubles instead of singles." And he'd say, "Aw, Bill, you know I'm not as fast as you." And I really thought he wasn't as fast as me. And then came the day, late in the season, it's the last game with the Yankees and we have a field day. There's Foxx, Cook, and myself running for Boston and Ben Chapman and Jake Powell and Merrell Holden for the Yankees, and the starter says, "On your marks, get set" and shot the gun off. I stole about a yard and I expected to hear the gun go off again to take us back [to the starting line] but it didn't. And then all of a sudden after about 85 yards, I felt someone coming up on me, and I thought it was Chapman. But it wasn't Chapman, it was Foxx and he won $100. He was a great one!

—Billy Werber

Starting in 1936, Jimmie Foxx knocked in 100 runs in each of his six full seasons with the Red Sox, and, when added to his seven previous 100-RBIs seasons with the Athletics, he is the third player to have at least 100 RBIs in 13 seasons (joining Babe Ruth and Lou Gehrig). He played for Boston until 1942. In 1945, he retired from baseball with 534 home runs, 1,751 RBIs, and a .325 batting average. Foxx was the MVP in 1938 when he led the league with a .349 average and 175 RBIs and hit a then club record 50 home runs.

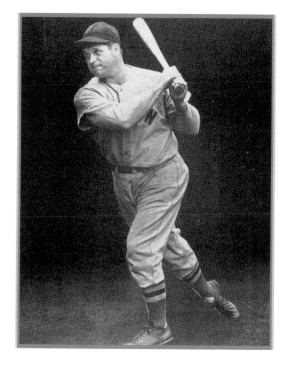

From the Baseball Magazine Collection of
the Boston Public Library, September 1938

The first time I saw Ted [Williams] was in 1936, the Hollywood team moved from Hollywood in the winter of 1935 to San Diego. When school was out in June, I remember Ted standing in front of me. I didn't know who he was, just the big string bean kid, six foot three inches, 147 pounds, and the manager of the club said, "Let the kid get in and hit a few." Of course, all the old-time players around there were ex-major-leaguers and they were grumbling about the kid taking up their time at batting practice. Anyway, Ted got in and hit probably a half dozen balls, all line drives, and that made quite an impression . . . and then everybody started asking who's this kid. That was on about a Thursday, and we were traveling north to Oakland to play a game on Monday night. Down at the train depot, there's Ted prancing up and down, so we knew he had signed and it seemed like he said he'd signed for $125 a month. That's where I first got to meet Ted. And then we became friends. He liked the movies and we were about the same age, so we got pretty well acquainted.

—Bobby Doerr

Ted Williams (left) is shown here with good friend Bobby Doerr. Williams is commonly referred to as the greatest hitter of all time. He was the MVP in 1946 and 1949, the batting champion in 1941, 1942, 1947, 1948, 1957, and 1958, the home run champion in 1941, 1942, 1947, and 1949, and the RBI leader in 1939, 1942, 1947, and 1949, among other accomplishments. His No. 9 was retired by the Red Sox in 1984.

Leslie Jones photograph, from the Leslie Jones Collection of the Boston Public Library, *c.* 1939

Joe Cronin was great to play for, but we didn't have a very good ball club [in 1945]; we ended up in seventh place that year. I enjoyed playing for him, we had a great bunch [of guys] and they were mighty good to me. I had just come out of the service and got a good break getting into the major leagues so quickly after coming out and having only one season of minor-league baseball. We were looking forward to the big guys coming back the next year [1946], which they did.

Ted [Williams] was just awesome. It was a great thing to watch him play every day and to hit. He's just one of a kind. He worked so hard at the game and everything, he analyzed those pitchers and studied them, and you would hear him talking in the dugout to all the hitters about the pitchers. And then watching some of his most memorable feats, I got to see some of his greatest feats during my time with the Red Sox. He's just a great teammate and a great guy.

—Boo Ferriss

Joe Cronin (right) was traded to the Red Sox prior to the 1935 season. He finished playing in 1945 but remained a manager until 1947. Over his career, Cronin batted .300 or higher eight times, as well as knocking in 100 runs or more eight times. He finished with a .301 average, 170 home runs, and 1,424 RBIs. As a manager, he compiled a 1,236-1,055 record and won two American League championships (in 1933 and 1946). He succeeded Eddie Collins as general manager of the Red Sox and served until 1958. In January 1959, Cronin was elected president of the American League, the first former player to be so elected. Cronin served as American League president until early 1973. The Red Sox retired his No. 4 in 1984.

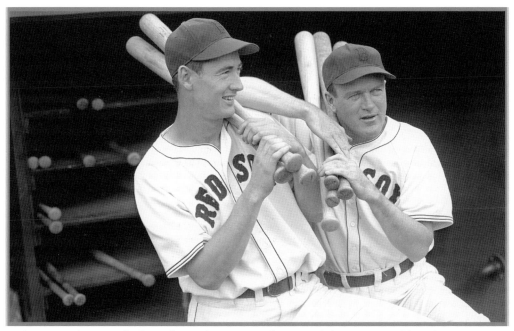

Leslie Jones photograph, from the Leslie Jones Collection of the Boston Public Library, c. 1940

William Dale (Billy) Goodman was an infielder and left-handed batter who played with the Boston Red Sox for 10 years starting in 1947. Goodman was an extremely versatile player capable of playing at almost every position. In 1950, he led the American League in batting average with a .354 mark and was runner-up in voting for the MVP award. He also hit .290 or better 11 straight years. In his career, Goodman batted exactly .300, with 19 home runs, 591 RBIs, 807 runs, 1,691 hits, 299 doubles, 44 triples, 37 stolen bases, and 669 walks for a .376 on-base percentage and was a two-time all-star. Goodman is shown here on third base before a game at Yankee Stadium.

From the Red Sox Archives, *c.* 1940s

He [Williams] tried to convey to Bobby [Doerr] that you should try to swing up on the ball instead of leveling off, and I used to listen to these conversations and discussions, and every once in a while I would say, "But Teddy, nobody swung at a baseball in the same manner that you do." And they didn't. Ted had a method and manner of swinging up and then over the ball; however he did it, beats me . . . and if he hit the ball on the top of the baseball it would either sink over an infielder's head like a ton of lead or go through the infield like a bullet, but if he hit the ball underneath, then the ball would majestically fly into the air for a long distance. So he was unusual in that respect.

—Dom DiMaggio

Good friends Bobby Doerr, Ted Williams, and Dom DiMaggio, from left to right, are all pictured here showing off their reach. Note Williams's shortened sleeves. He felt that the length of the sleeves of the uniforms restricted his swing and thus cut the sleeves back.

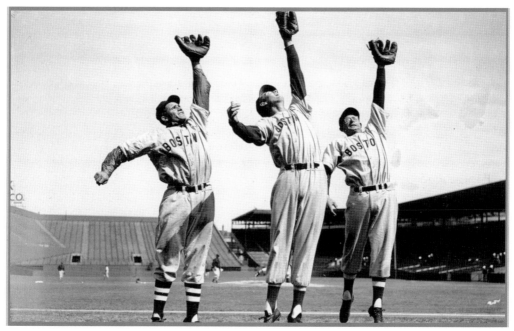
Leslie Jones photograph, from the Leslie Jones Collection of the Boston Public Library, 1940

I came in off the sandlots of San Francisco into the Triple-A Pacific Coast League [PCL], which at the time was the highest minor league in the country. To me, as I think back now, it was quite a jump. I wasn't a very big guy, and I stepped right in from off the sandlots and went to a camp that the Seals were holding in conjunction with the Cincinnati Reds, and the San Francisco Seals had first choice and selected me. Now, whether they selected me because I had two brothers in the major leagues, or whether they thought I might have some potential, I'm not sure.

I had to make the breakthrough to the PCL while wearing glasses. Once I came to the majors, I had to do the same thing all over again. As far as I was concerned the glasses were not a hindrance, but everybody else at the time seemed to [think] that it might be. Back then, young fellas wearing glasses were not typical timber for professional athletics. So I kind of feel, that in my own way, my breakthrough not only in the PCL but then going from there into the major leagues and making it with the Boston Red Sox opened up the floodgates for all young kids who aspired to be professional athletes who wore glasses.

—Dom DiMaggio

Nicknamed the "Little Professor," Dom DiMaggio joined the Red Sox in 1940. He was a seven-time all-star and played with them until he retired in 1953.

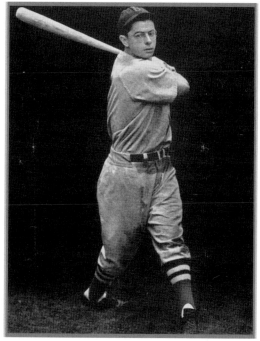

From the Baseball Magazine Collection of
the Boston Public Library, April 1941

When I was playing, I only hit 17 home runs, 6 [of them] around the pole. When you hit as few home runs as I hit, you remember every one. Mel Parnell was a great pitcher on the '48 team and went into broadcasting when I was managing the minors. Well, I was in the ballpark one day and someone hit a ball down the right field line to win the ball game for the Red Sox. As the game ended, Parnell and Ned Martin were the announcers and they talked about the home run and Mel said, "In 1948, Johnny hit a home run around that pole in right field and we called it the Pesky pole." And it stuck.

—Johnny Pesky

Johnny Pesky joined the Red Sox in the 1942 season and, with a break of three years for the war, played with the Red Sox until 1952. He is pictured here posed for *Baseball Magazine*'s inside back cover.

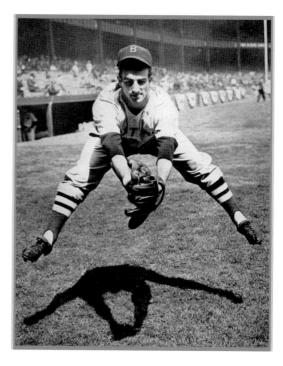

From the Baseball Magazine Collection
of the Boston Public Library, July 1942

I started that game [the All-Star Game in 1946]. We had a lot of players, but I played 3–4 innings. I went 0-1, hit a ground ball to second base. I'll never forget that, that was my tour in my first All-Star Game. I played in a couple of others afterwards, but that was my first year and the one you remember the most. Williams had a great day that day, hit a home run off the blooper pitch, and we beat the National League pretty good that day. I remember what he [Ted] did, he sat back in the box and took a little hop toward the pitcher's mound and he hit the ball and the ball just kept going into the bullpen. And it was really something to watch him hit the ball the way he did, the pitch was just tossed up there, an off-speed pitch that was about 8 to 10 feet high. Of course, we were leading by a big score, I remember that very vividly.

—Johnny Pesky

Johnny Pesky is shown here visiting the Red Sox offices at Fenway Park while on furlough from the navy.

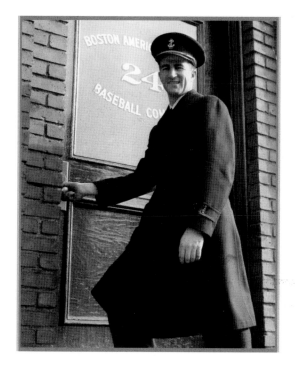

From the Herald-Traveler Photo
Collection of the Boston Public Library,
December 1943

The first game I played in Yankee Stadium was June 22, 1930. I was hitting second against St. Louis with [Babe] Ruth hitting third and then he hit a ball in the right field stands, and I knew it was a home run when he hit it, but I said to myself, I'm going to show these Yankees how to run. So, I took off with a head of steam and rounded second and rounded third and Art Fletcher from third base was hollering, "Hold up, Hold up," but I kept on going. I crossed home plate and came and sat down in the Yankee dugout, and when Ruth came in, he patted me on the head and said, "You don't need to run like that when the Babe hits one."

—Billy Werber

Two of the greatest players of all time are seen here together. This image was taken prior to a war charities game at Braves Field. During World War II, Babe Ruth (left) became a spokesman for United States war bonds and played in a number of benefit baseball games to raise money for the war effort. Ted Williams was a marine flyer during World War II and missed the 1943–1945 baseball seasons.

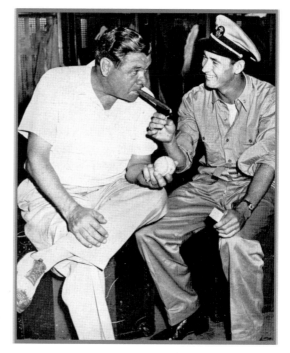

From the Baseball Magazine Collection of
the Boston Public Library, October 1943

Ted [Williams] went up to the Red Sox [spring training] in 1938 and then was sent to Minneapolis and came back in 1939, and then I came up in '40. Bobby [Doerr] had already been with the Red Sox, and then in '42, Johnny [Pesky] came up. So we all got together—all West Coast boys; of course Johnny was the second batter, I was the leadoff, and it was like two minds in one. I knew almost exactly what he was going to do, and he knew exactly what I was going to do. So we had a real good thing going there, and of course, we had the power behind us. We had Williams, Bobby Doerr, Rudy York, Jimmie Foxx, we had all those power hitters behind us and we were sort of the "table setters." Although the strange part of it was, the only year I batted out of the leadoff spot was in 1946 when I batted third and we won the pennant, but I never batted third again.

—Dom DiMaggio

Ted Williams is shown here with power-hitting teammates Bobby Doerr (right) and Rudy York (left). Each had over 100 RBIs before the end of August 1946.

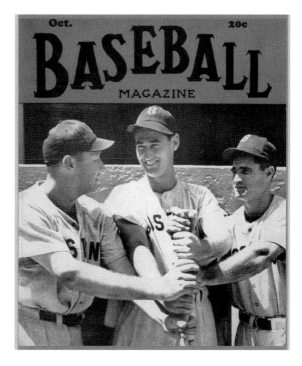

Acme photograph, from the Baseball
Magazine Collection of the Boston
Public Library, October 1946

1946 was quite a thrill coming back to play baseball [after the war]. Ted [Williams] had missed three years, as had [Johnny] Pesky and Dominick [DiMaggio]. I only missed about a year, the last month of '44 and all of '45, so I didn't miss that much. But they all came back good. Some of them, Dom and Pesky in particular, played some baseball. I don't think Ted played too much though, but they came back strong and we got off to a good start. I think we only lost 16 games at home that year. It just seemed like . . . we were playing really aggressive ball. Everybody was happy, of course, we were out in front by quite a few games, and a lot of times on those really hot days, you would come to sit down on the bench and some ballplayer sitting on the bench would get a soaking wet sponge and slip it under you and then you were sitting on a wet sponge. When you were that far ahead, it seemed like we were horsing around having a lot of fun.

—Bobby Doerr

This photograph of the 1946 Boston Red Sox ran in *Baseball Magazine*.

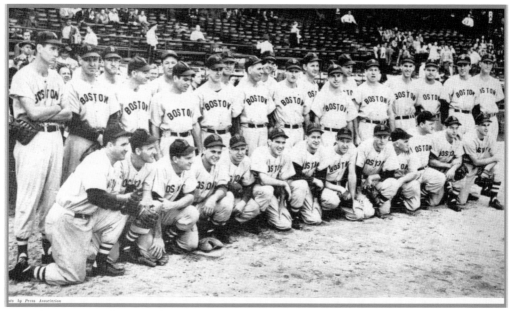

Press Association photograph, from the Baseball Magazine Collection of the Boston Public Library, December 1946

My most memorable game, my biggest thrill, was the opportunity to pitch in the 1946 World Series after we had won the American League pennant. It was Game 3, and we had split out in St. Louis during the first two games. I think any boy's dream is to pitch in the World Series, and pitching for the Red Sox in Fenway against the Cardinals—that was a tremendous thrill. Fortunately that was a good day and I went all the way with a six-hitter, I think it was, and won 4-0 and that put us up in the series 2-1.

Earl Johnson got credit for the first game. Tex Hughson had started the first game out in St. Louis, and Earl Johnson came in in the late innings when Rudy York broke the tie in the 10th inning with a home run. And Joe Dobson won the fifth game in Fenway, and that put us up ahead 3-2 with the series going back to St. Louis. Of course, we lost those two games out there by close scores.

I only pitched in one World Series, but we came close—we lost a playoff game to the Indians in '48. And, of course, '49 we lost by one game to the Yankees. So the '46 World Series was the only one I was in.

—Boo Ferriss

Dave "Boo" Ferriss is shown here with Joe Dobson (center) and Earl Johnson (right) during the 1946 World Series. He played with the Red Sox from 1945 through 1950.

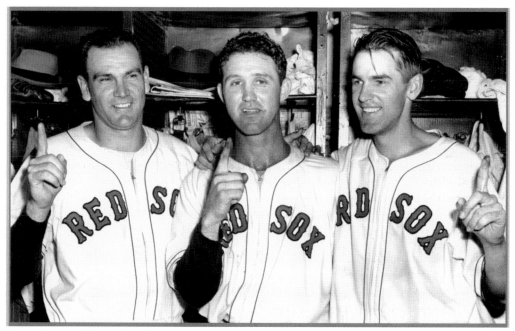

From the Herald-Traveler Photo Collection of the Boston Public Library, October 1946

In 1946, Tex Hughson helped the Red Sox have their best season in 28 years. He won 20 games that year and teamed with another 20-game winner in Boo Ferriss. Between the two of them, Ferriss and Hughson pitched in 79 games. They won a combined 45 games, threw 47 complete games, had 12 shutouts, and even earned three saves each. Hughson led the team in ERA, and the Red Sox won 104 games as they destroyed the competition to win the American League pennant. In their first World Series since 1918, the Red Sox were favored over the St. Louis Cardinals, who struggled to win the National League pennant. In Game 1, Hughson paced the Red Sox to the extra-inning win with a terrific performance, in which he gave up only two runs through eight innings. Four days later, the Red Sox were up two games to one, and manager Joe Cronin called on Hughson to pitch on three days rest, a normal request in the World Series; Hughson, however, was hit hard. Lasting only two innings, he was one of six pitchers who gave up 12 runs on 20 hits and allowed the Cardinals to tie the series at two games apiece. In Game 6, the Sox had a chance to clinch the World Series victory, but starter Mickey Harris was chased out of the game, and Hughson came on to pitch 4.1 scoreless innings in relief. This appearance made him unable to pitch in Game 7 when the Red Sox lost the game and the World Series. This photograph depicts Hughson pitching from the sidelines at Fenway Park.

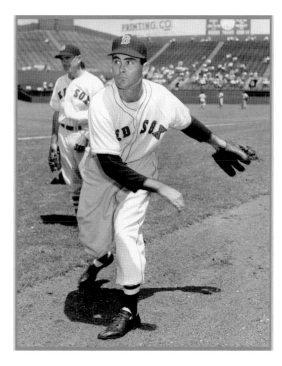

From the Herald-Traveler Photo
Collection of the Boston Public Library,
July 16, 1948

My most memorable game, of course, is the no-hitter. It's something every pitcher dreams of, and you never expect it to happen. I've heard pitchers say that they didn't know they were going for a no-hitter, but I can't believe that because you have to know, the fans remind you, you got a big scoreboard in the ballpark to look at, there are so many reminders. In my case, in the seventh inning Jackie Jensen came in to me and said, look fella you got a no-hitter going, don't let them hit the ball to me in right field because I don't want to be the guy to mess it up for you. I tell him, "Jackie forget it, I'm just looking for a win, that's all I'm interested in, if it happens it happens." And then on the last play of the game, the ball is hit back to me, by Walt Dropo, a former teammate who was with Chicago who had come in to pinch-hit. He hit a ground ball back to me on the first base side of the mound and I caught the ball and ran to first base and made the play unassisted. When I got to first base, Mickey Vernon, our first baseman, said, "What's the matter, you didn't trust me?" I said, "I got all the confidence in you, but I don't trust myself, under the circumstances I may just throw it away."

—Mel Parnell

This photograph shows Mel Parnell throwing batting practice from the mound at Fenway Park, the left field wall is visible behind.

Dick Thompson photograph, reprinted
with permission from the New England
Sports Museum Collection, 1949

It was quite a thrill (my rookie year) because I used to keep pictures of most of the players and put them on my bedroom wall. Then here's Jimmie Foxx, and [Lefty] Grove, and [Pinky] Higgins, and [Doc] Cramer, and all those great ballplayers. In fact, I think they were still on my bedroom wall when I joined the club in 1937. It was quite a thrill walking into that ballpark and seeing Jimmie Foxx hitting balls and then see Joe Cronin, the manager. Hugh Duffy was a coach at that time. I remember him hitting me balls, he hit one to my right and one to my left; I was in pretty good shape because I worked out before I got down there in Los Angeles where my folks lived, but my gosh, he would hit me balls to my right and my left and my right and I didn't think he was ever going to quit.

I'll never forget, back then the offices were right behind third base in the stands there and Cronin took me out of the office and we stood in back of the stands. And he said, "This is what you're going to be looking at now for some time," and oh what a thrill it was to see that ballpark, it was just so beautiful. Back then they had signs on the left field wall, advertising signs. It was just such a thrill, and I can see just like it was yesterday.

—Bobby Doerr

This image of Lolly Hopkins, shown here with Bobby Doerr at Fenway Park, is unusual because she is known as the Boston Braves' biggest fan and attended almost every Braves home game.

Leslie Jones photograph, from the Leslie Jones Collection of the Boston Public Library, c. 1950

The first time I walked to the mound in Fenway, I looked at the left field fence and I thought I made a mistake [signing with Boston] because I had been scouted by the St. Louis Cardinals as well, and I thought, "Man, what a mistake I made because I'm going to be pitching in this ballpark." But I couldn't have made a better choice than signing with the Red Sox because it is a great organization and a great bunch of fellas to play with and play for.

I enjoyed pitching in Fenway Park. I know the left field fence was close, but I kept the ball in tight on right-hand hitters, and the reason I did it was simply because I was keeping their arms closer to their body. If I missed the inside corner, I was usually inside a little bit and a hitter would go for that pitch. But if you miss the outside corner, then you are right down the middle of the plate and the hitter gets a chance to swing with his arms extended and that's power. So by keeping the ball in tight, I think it kind of kept the hitters swinging with the arms bent a little bit, and naturally they weren't able to get power into their swing.

—Mel Parnell

Mel Parnell is shown here with Ellis Kinder (right), giving advice to Maurice McDermott (center), a promising young pitcher. Mel Parnell joined the Red Sox in 1947, was the ERA champion in 1949 when he had a 25-7 record, threw a no-hitter, and after retirement became a very popular broadcaster with on-air partner Ned Martin.

From the Baseball Magazine Collection
of the Boston Public Library, 1950

Ted [Williams] and I came to spring training together in 1938. Eddie Collins wrote me a letter and asked if I would bring Ted to spring training. That year, the train tracks got washed out with a big flood the day before we were supposed to leave, and I didn't know how to get in touch with him. Well, he [Ted] had a HAM operator call me up in L.A., and I said the best thing to do was—you go the best way you can go and I'll go the best way I can go. So I took a bus out to the Palm Springs area to get on the train there, and Babe Herman and Max Webb were on that train. We ended up going to dinner in El Paso and when we came back, well here's Ted prancing up and down by the train tracks. His train had caught up with ours and so [we went together the rest of the way]. Of course, Ted was pumping Babe Herman for everything he could find out about hitting.

[When we arrived,] I took Ted over [to meet Joe Cronin] and said, "Joe, I'd like to have you meet Ted Williams," and Joe said he was happy to have Ted there, and Ted came back with, "Hi, sport." And afterwards I thought that was probably his ticket to join the Minneapolis club [Triple A]. He had that great year in Minneapolis, and then he came up and joined us in 1939.

—Bobby Doerr

Bobby Doerr is shown here giving batting tips to Catholic Youth Organization girl all-star softball players at Fenway Park. Doerr joined the Red Sox in 1937 and played with them until 1951, when he retired. His No. 1 is retired, and he is a member of the National Baseball Hall of Fame.

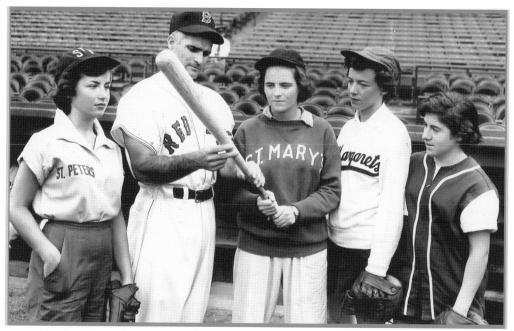

From the Herald-Traveler Photo Collection of the Boston Public Library, August 1951

Before joining the Red Sox, Harry Agganis, also known as "the Golden Greek," was a superstar football and baseball player for Lynn Classical (Massachusetts) High School and for Boston University. In fact, he was such a star in high school that he had a fan club his senior year. He only played in 157 games over two seasons for the Red Sox, but he became a legend. When contemplating what to do with his life after college, he had two options to choose between, play football as the Cleveland Browns' first draft pick and replace legendary quarterback Otto Graham or pursue baseball with a much less assured future. Despite the Browns' offer of a $100,000 contract and a $25,000 bonus, he chose to sign with the Red Sox. As a rookie, Agganis was great defensively at first base but struggled at the plate as he hit only .253 with 10 home runs and 57 RBIs. Many rookies have a tough time adjusting, and when the 1955 season began, Agganis's numbers improved vastly. He was hitting .313 through 25 games and already had 10 doubles, only 3 behind his full-year total in 1954. Unfortunately he then was stricken with an unknown illness. Agganis was hospitalized on May 25 with a cold that soon grew into a lung infection. He was released briefly but soon readmitted on June 7. After 20 days fighting the disease, he fell unconscious on June 27 and died at age 26 of what was determined to be a pulmonary embolism. His impact in the city is still seen in the naming of Boston University's new sports complex, Agganis Arena, which is on Agganis Way.

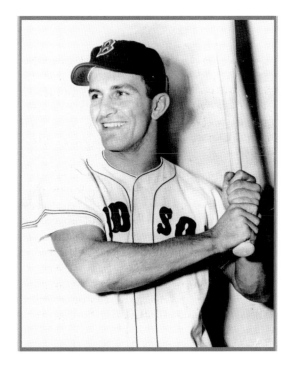

From the Red Sox Archives, *c.* 1954

Jackie Jensen was a superb athlete and has the distinction of being one of two men to have participated in the baseball All-Star Game, the World Series, and the Rose Bowl. He was a two-sport star at the University of California where he led the baseball team to the first College World Series and the football team to the 1949 Rose Bowl as a running back. He started in the major leagues with the New York Yankees and took part in the 1951 World Series. He was then traded to the Washington Senators, where he excelled in the outfield and at the plate, making the all-star team in 1952. He moved on to the Red Sox after the 1953 season and continued his strong play. Just before he joined the Red Sox, a plane that he was traveling on nearly crashed, and Jensen was affected with a fear of flying that plagued him forever. He even debated playing in the 1954 season at all. But manager Lou Boudreau prevailed on him to play, and general manager Joe Cronin allowed him to travel to games by train or car when it was practical. He never overcame his fear of flying but did not let it ruin his career. In 1958, Jensen won the MVP award with a .286 batting average and league-leading totals of 122 RBIs, 35 home runs, and 31 doubles. After another solid season in 1959, Jensen retired to spend time with his family, but the lure of baseball proved too strong and he returned for one more season in 1961 before hanging up his cleats for good. Jensen is shown here signing autographs for fans as they line up on the outside of the fence near Van Ness Street.

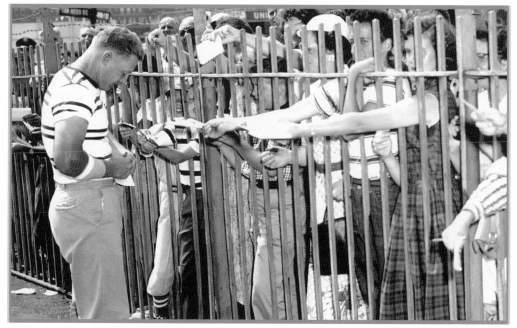

From the Herald-Traveler Photo Collection of the Boston Public Library, August 4, 1955

My first game in Boston was a day-night doubleheader on Patriot's Day. The morning game would start after the beginning of the Boston Marathon at 10:00, and then we'd play again at 2:30. In the morning game, I hit my first home run at Fenway . . .

In 1952, the organization invited about 20 prospects to spring training. The first guys we met were Billy Goodman and Mel Parnell. We were thinking we were going to get sent down at any time, but it worked out that we all stayed together. You never really felt comfortable unless you were a superstar because you could always get sent down [to Triple A]. You could go up and down like a yo-yo. We were all at that risk.

I achieved a lifelong dream [playing in the big leagues]. I remember a lot of things—my first home run, my three grand slams, the pinch-hit home run that won the game. But it was really just about playing [the game]. I played with Ted Williams for several years—I felt very honored to be on the field with him, and anytime you stepped on a field with him, you had a chance to win. I liked playing [in Boston]. I think when you show the fans that you're out there hustling, playing hard, and busting your fanny, they notice it and appreciate it.

—Ted Lepcio

Ted Lepcio is shown here with teammate Walt Dropo, tobogganing at Grossinger Country Club in New York. Dropo was the American League Rookie of the Year in 1950.

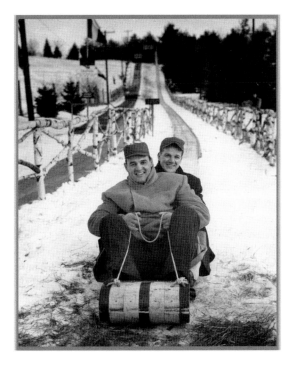

From the Herald-Traveler Photo
Collection of the Boston Public Library,
January 1956

The first time I played in Fenway Park was definitely my most memorable game. It was July 24 against Kansas City. I was leading off . . . I had seen the pitcher before in the minor leagues. My first at bat was very thrilling for me. I got a rousing ovation when I got up to the plate—a standing ovation. A lot of things went through my mind. I can remember thinking to myself, "I really don't want to strike out right now." I really wanted to hit the ball . . . I hit in through the hole in the infield, and it made me feel good.

I knew about Jackie Robinson. He was the one I had thought of mostly. He played minor-league [ball] in my hometown in the Pacific Coast League. They had a lot of black ballplayers in that league. So I knew a lot of them from the games. I liked Jackie and learned a lot from him. I learned a lot from a lot of ballplayers. He got on the Dodgers, and I became a Dodger fan.

There were a bunch of good guys on the Red Sox. Ted Williams—he would talk to you and give you advice on any matter, even things not about baseball. The whole team was one unit when we walked out on the field. They were supportive of me whenever we played a game.

—Pumpsie Green

Pumpsie Green was the first African American to play for the Red Sox. He is shown here with Earl Wilson (left), who pitched a no-hitter in 1962, the first by an African American in American League history.

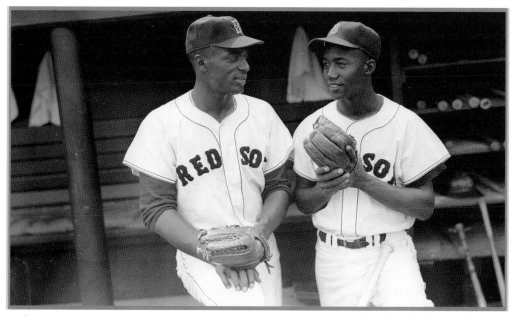

Leslie Jones photograph, from the Leslie Jones Collection of the Boston Public Library, August 30, 1959

It was a great honor to get to step out onto the field . . . my first game playing for the Red Sox was a doubleheader against the Baltimore Orioles. I ended up getting four hits that day. And, you know, . . . seeing the Green Monster . . . that always hits the spot.

My first spring training I remember meeting Ted Williams and Jackie Jensen. Ted Williams was the first guy to come over and say, "Hey, welcome to the ball club. I hope things work out." He did say that he had read about me when he was in Hawaii where I was stationed. I mean, it was just great for me to have him come over and welcome me to the ball club. He was just a gentleman. I was fortunate enough to play with Ted Williams for five years, and I got to play during Carl Yastrzemski's first five years. I had some pretty good outfielders playing behind me.

One game that sticks out was my first All-Star Game. Ted Williams and I were the only two players from the Red Sox on the team that year. I didn't know what to expect . . . I had never been there. Ted said, "We were picked to represent the American League, and they want to win the ball game." That's the way you have to approach the game. Because if you don't, you won't play the way you're capable of.

—Frank Malzone

From left to right, Frank Malzone is shown here with Don Buddin, Pumpsie Green, and Pete Runnels, the Red Sox infield. Malzone won three consecutive Rawlings Gold Gloves. Runnels was batting champion in 1960 and 1962.

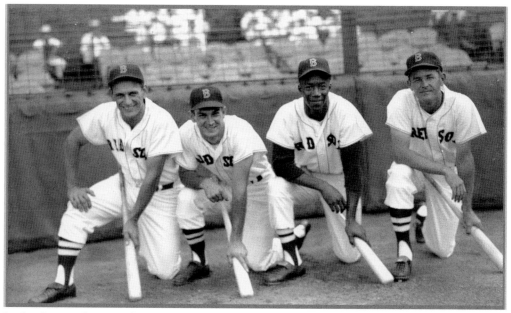

Leslie Jones photograph, from the Leslie Jones Collection of the Boston Public Library, August 4, 1959

I remember flying in that afternoon [of the no-hit game on August 1, 1962], which we did a lot of, and the stewardess helped me with the crossword puzzle and then she said, "How are you doing?" "Oh boy," I said, "I'm struggling a little bit. I haven't won a game in a long time." She said, as she was getting up to leave, "Well, you'll pitch a no-hitter tonight." And so, I said, "Oh yeah." And anyway, the rest is history, and that's what happened. It was the biggest thrill I ever had, of course. The thing about it was that facing Early Wynn, I think he was going for his 298th win, I knew I was in for a battle, and it was 0-0 going into the eighth inning. We scored and it was a bang-bang play at home plate. I don't think anyone would have complained if they had called him out, but he [the umpire] happened to call him safe. The final out was Luis Aparicio, and I had him 0-2 and I threw him a slider. It was a check swing, and it was obvious that he had gone through and committed himself. But maybe they just didn't want to end it that way. The umpire's name was Bill McKinley, and he called it a non-check swing, and as the ball was being thrown back to me, I heard someone yell from the stands, "They shot the wrong McKinley." So I had to back off the mound to regroup, and I did get a little chuckle from it myself, but then I threw him another slider and he swung and missed, and they said I went about six feet off the ground and I doubt that but . . . that's the way it was and what a wonderful ending.

—Bill Monbouquette

Bill Monbouquette was a four-time all-star and played 10 years for the Red Sox. He is shown here several days after pitching his no-hitter against the Chicago White Sox on August 1, 1962.

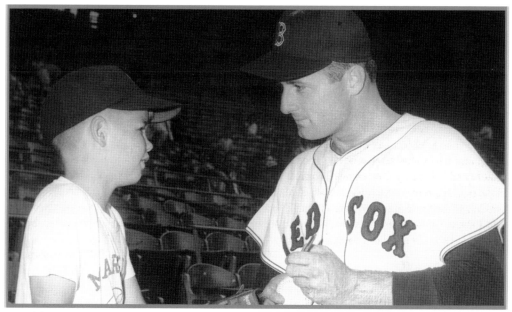

Ronald Donovari photograph, from the Herald-Traveler Photo Collection of the Boston Public Library, August 9, 1962

Dick Radatz, known as "the Monster," captured the hearts and imaginations of the Boston sports fans when he broke into the majors in 1962. He instantly became the best reliever in baseball, with his imposing physique at six feet five inches tall and 230 pounds along with a darting fastball and deceptive slider. While in the minors, he struggled as a starter so much so that his manager at Triple A Seattle, Johnny Pesky, suggested he move to the bullpen so that he did not have to hold anything back. In his first appearance in relief, he struck out 11 of 12 batters. The next season, as a rookie for the Red Sox, his first few appearances were just as impressive: in his first 4.2 innings, he struck out eight batters, walked two, gave up only one hit, and did not allow any runs to score. He soon became one of the most enduring pitchers in baseball. His ability to pitch 130 innings a year is a feat that few relievers could ever replicate. As a closer in the 1960s, he often pitched more than the requisite one inning that today happens so often. Instead Radatz usually came in to pitch in the seventh with men on base. In one extra-inning game, he pitched nine innings in relief. His win-loss records look like those of a starter; he earned many decisions because he would pitch three or four innings in a game. Twice in his career he had double-digit wins, with 15 (25 saves) in 1963 and 16 (29 saves) in 1964. He racked up 104 saves in the more than four years with the Red Sox. He also totaled 627 strikeouts in 557.1 innings pitched during that time. Radatz became an icon on sports radio after his baseball career ended. Radatz was named Fireman of the Year during his rookie season and again in 1964. He was also named to the all-star team in 1963. Radatz is shown here being awarded a badge from a fireman before a game at Fenway Park.

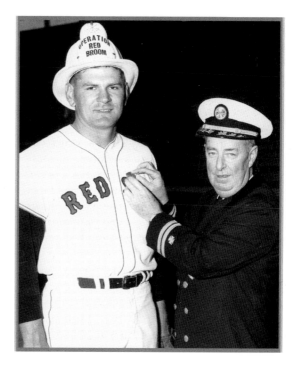

From the Red Sox Archives, *c.* 1965

In 1967, I was a young teenager, and I was locked in like everyone else in the city with that team because they had been a last-place team the year before. Dick Williams took over as the manager and brought a bunch of kids up from Toronto, which was the minor-league team, and I went to opening day and the place was less than half full. Nobody expected anything out of that team, and I remember Williams saying, "We're going to win more than we lose." Obviously as the season went on and on and on, it was incredibly exciting. I remember they won on a road trip, and when they got back, thousands of people were waiting for them. That's the year that I really became obsessed with Red Sox baseball because of Yaz, the kind of year he had, Joe Foy, George Scott, Mike Andrews, Reggie Smith, Conigliaro, Elston Howard—in some ways, I remember that year better than the years I played. That's what really hooked me as a teenager into the Red Sox.

My favorite player was Yaz, he won the Triple Crown that year. Actually, I liked them all, I fell in love with that team. At that age, I was a player myself, just getting into Babe Ruth League and, of course, I was dreaming about the possibility of being here. So everything I did as a player then was to do it the way these guys did it up here.

—Jerry Remy

Carl "Yaz" Yastrzemski won the Triple Crown in 1967, leading the American League in batting average, home runs, and RBIs. He was also the batting champion in 1963 and 1968. He was the MVP in 1967 and hit for the cycle on May 14, 1965. His No. 8 was retired in 1989.

From the Herald-Traveler Photo Collection of the
Boston Public Library, August 1967

My favorite memory of 1967 was being on the mound the day we clinched the American League pennant on October 1. We played the Twins and faced Dean Chance that day. We were down 2-0 going into the bottom of the sixth inning. I led off with a surprise bunt hit, and then we had three successive singles. Yaz knocked in two runs to tie the score, and we went on to score three more runs to go ahead 5-2. Being on the mound when Rich Rollins popped up to Rico Petrocelli, knowing that we won the game and we were at least assured a tie going into the American League championship, all the players coming over to celebrate on the mound, and then all the fans being on the field, there were thousands of them. To get carried off the field by the fans was like a kid's dream come true. It was a very special moment.

—Jim Lonborg

"Gentleman Jim" Lonborg is shown here with students from the Greater Boston Academy. Lonborg was the strikeout champion in 1967 with 246 strikeouts, as well as being the American League Cy Young Award winner that same year.

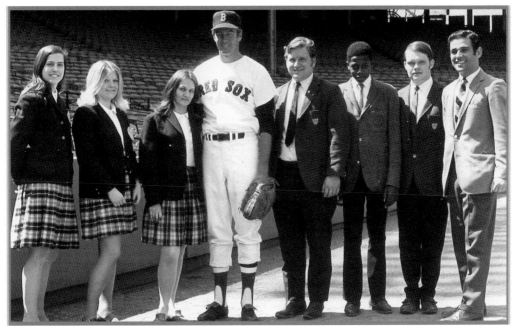

From the Herald-Traveler Photo Collection of the Boston Public Library, May 1970

It was one of the nicest five or six weeks that I ever had in terms of baseball [the end of the 1967 season]. I wasn't involved as much as I would have liked to have been, but the young talent that was on that team was so good that it was just nice being up. No one, no one, absolutely no one has ever been more valuable in one year than Yaz was to that team. It was just incredible. He had a great array around him. [Jim] Lonborg had a phenomenal year. [Jose] Santiago had a great year. Rico [Petrocelli], Tony C. before he got hurt, [Mike] Andrews, Reggie Smith, it was a young group of guys who, had they stayed healthy, could have had one of those two- or three- or four-year runs. [I remember the 1970 All-Star Game] . . . three catchers were taken. [Bill] Freehan was the choice of the people . . . [and] started the game because he was elected, and [Ray] Fosse came in and that was the play when Pete Rose ran over him at home plate. I didn't get into the game. [If it had been me,] I guarantee he would have never run over me. I had played an awful lot of football before that time, and I had prepared. I got run over once in A-ball, and I swore that that would never happen again and it never did. It was great being there. It was fun being among the elite. But most memorable for me was that Yaz went four for six in that game, played the whole game, which I think was 12 innings or whatever it was, and he was the Most Valuable Player on the losing team. I was just in awe.

—Jerry Moses

Red Sox catcher Jerry Moses is pictured in his car with his dog while talking to Dick Schofield.

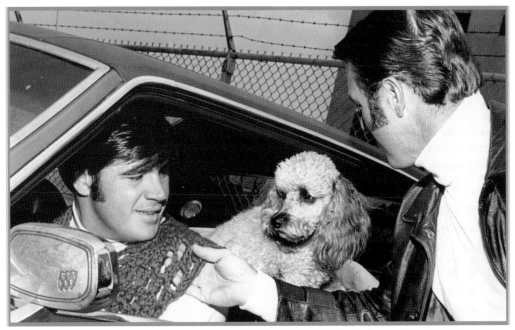

From the Herald-Traveler Photo Collection of the Boston Public Library, April 1970

The thing about that year [1967], like most teams having a good year, we had a lot of come-from-behind victories. So that coupled with our youth, our enthusiasm, and the fact that we were happy to be there—the last game of the year with a chance to win the pennant so we were loose. Coming into that game, guys were kidding around in the clubhouse and we had music on, guys were interviewing each other and just having a lot of fun. And we couldn't wait for the game to start so I think that was—anytime we got behind, we felt we would come back because we had the confidence. And of course, Carl Yaz had such a fabulous year, and he was just great. We had a lot of fun with him. Carl had won a batting title, and a lot of the young guys looked up to him.

I'll never forget the last out [of the last game of the 1967 season]. The ball was hit, it wasn't hit very high, it was hit off the handle, the hands, in the kitchen, as they say, of Rich Rollins and it didn't take long to come down. Although when you are looking up at the ball, the anticipation from the fans, you just couldn't wait until it went in the glove and it was out and that was it, the game was over. So I was very, very excited about having the ball hit to me. I think every fielder wants that, and I don't think I realized the significance of it in Red Sox history. Making that catch and people remembering it—it was really a big thrill.

—Rico Petrocelli

Rico Petrocelli is shown here in the clubhouse at Fenway Park. He played 12 years for the Red Sox and was inducted into the Red Sox Hall of Fame in 1997.

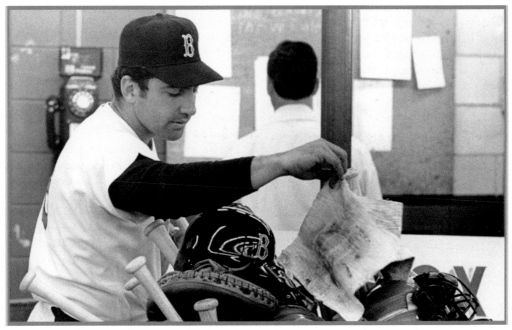

From the Red Sox Archives, *c.* 1970

Reggie Smith is considered one of the most underrated Red Sox players in history. He made his major-league debut in 1966 and played six games that season. In 1967, as a rookie, he hit two home runs in the World Series against the St. Louis Cardinals. During his Red Sox career, Smith, a switch-hitter, batted .300 or better three times and won a Rawlings Gold Glove in 1968 after leading all American League outfielders with 390 putouts. The two-time Red Sox all-star also led the American League in doubles twice, with 37 in 1968 and 33 in 1971. Smith spent eight seasons with the Red Sox and played an additional nine years for the St. Louis Cardinals and Los Angeles Dodgers. Smith is shown here signing autographs for loyal Red Sox fans.

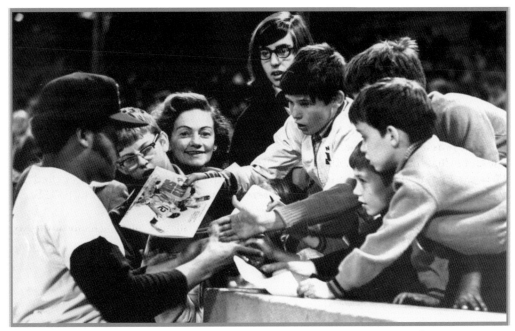

From the Herald-Traveler Photo Collection of the Boston Public Library, October 1970

In 1969, I went to spring training with the major-league team. I didn't have really a good year in the minor leagues [the year] before that, but I did so well in spring training that . . . the only reason I did so well was because that's when Tony worked with me. We went down three weeks before spring training, and he worked on my swing because I had a couple of things wrong with it. So when I went to spring training, I was way ahead of the game, I really did well, I think I hit about .400 in spring training. So the Red Sox decided to keep me on the team, but there was no place for me to play 'cause there was Tony in right, Reggie Smith in center, and Yaz in left. So I started off just playing when somebody was hurt. I was hitting .314 in the little time that I did play. So at the end of April, they decided to send me down to Louisville Triple A. I was kind of disappointed, but it was for my own good because I had a real good year down there. I hit .298 and had 81 RBI, so that really helped me get set up for 1970 when they brought me up to stay. I played pretty regularly [in 1970], I had 18 home runs and a pretty good year.

—Billy Conigliaro

Billy Conigliaro and his older brother Tony (left), shown here, played together for the Red Sox in the 1970 season. Billy was the first draft choice of the Red Sox in June 1965, the first year of Major League Baseball's amateur draft.

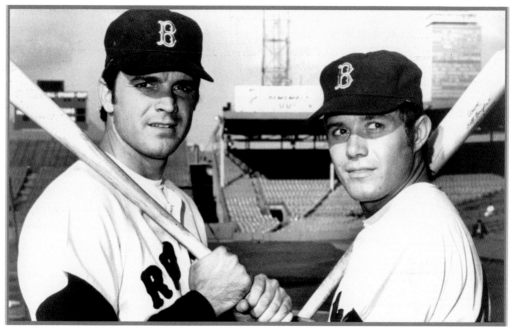

From the Red Sox Archives, *c.* 1970

I remember Paul Dowd was the general manager in Pittsfield, and he told me not to go on this two-day road trip because he knew I was going to get called up [to the majors]. I remember I came in in my '62 Chevy and I saw the ballpark. So I took my first right after the ballpark and then I took another right thinking I would get back to Fenway and I ended up in Cambridge. It took me a long time [to get back], and I missed the first game of the doubleheader. [When I finally got there,] it was during the intermission and I went out to the bullpen immediately for the second game. It wasn't a day-night back then, it was a straight doubleheader, and in the third inning we got in trouble, and [Dick] Williams [the manager] called down and I was in the ball game and I threw four and two-thirds innings of relief. It was a memorable game because the first two hitters took over 20 minutes. There was a delay after the first hitter, and the second hitter wrenched his back and had to be taken out of the ball game. And then George Scott made a miraculous catch, turned it into a double play on the third hitter, then I struck out the final batter and threw four scoreless innings, and Williams told me that I was going to be in the big leagues for a long time, and I was.

—Bill Lee

Bill Lee (left) is shown at Fenway Park talking to Carl Yastrzemski in the clubhouse. He played with the Red Sox from 1969 through 1978.

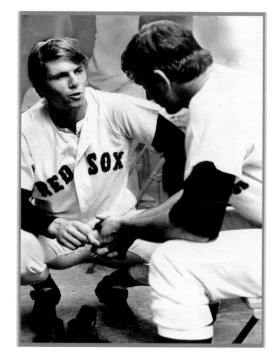

Donald T. Young photograph, from the
Herald-Traveler Photo Collection of the
Boston Public Library, August 22, 1971

First month of 1975 I had a terrific month. I hit over .300, I had 18–19 RBIs, and when he [Carlton Fisk] got healthy, of course, he came back and did most of the catching after that. It was a pretty good start of the season for me to fill in while he was injured. My memories of that team were that we didn't know what to expect when the season started. We had two rookies, a guy by the name of Rice, and a guy by the name of Lynn, and we didn't have any idea that those guys were going to become Jim Rice and Fred Lynn—we had no idea. They kind of set the tone as rookies for everybody else on that ball club to have great years. And personally, during the course of the year, all you can keep thinking about is going the World Series. If you have a chance to go to the World Series and you are a player in any sport at the major-league level, your ultimate goal is to get to the World Series and win one. Obviously, we didn't win one—but at least I got there at one point in my career.

—Bob Montgomery

Bob Montgomery is pictured here getting on his gear during spring training in Winter Haven, Florida.

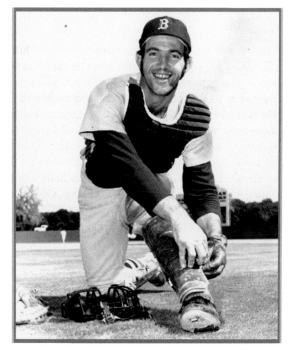

From the Herald-Traveler Photo
Collection of the Boston Public Library,
c. 1971

Rick Burleson garnered a reputation as one of the most intense shortstops in Red Sox history, characterized by his fiery play on the field. He became one of the best all-around shortstops in the American League during his Red Sox career. "Rooster," as he was nicknamed, was also one of the most enduring players. The three-time all-star played 1,004 games at shortstop. He and Everett Scott are the only two Red Sox players to play over 1,000 games at shortstop. Burleson holds the major-league record for most double plays in a season at shortstop with 147 and the Red Sox record for most career double plays for shortstops with 699. The former 1979 Rawlings Gold Glover came through at the plate in the 1975 American League Championship Series, as he hit .444 in the three-game sweep and .297 in the dramatic seven-game World Series against Cincinnati. Burleson (second from left) is shown here with the other members of the 1974 Red Sox infield at spring training: Rico Petrocelli (far left), Doug Griffin (second from right), and Carl Yastrzemski.

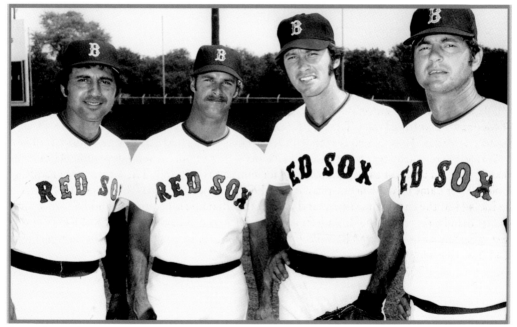

From the Red Sox Archives, Spring 1974

The Red Sox headed into Boston on the brink of elimination for Game 6 of the 1975 World Series; then the rains came. The World Series was postponed for three days due to the downpours. For Sox fans, however, Game 6 was worth the wait, as it produced one of the most magical moments in any World Series—Carlton Fisk's game-winning home run in the 12th inning. "It was very late," recalled Fisk. "I remember being in the on deck circle in the 12th with Fred Lynn before going up to bat. I had a strange but nice feeling and I said to him, 'Freddie, I feel good. I'm gonna hit one off the wall. Drive me in.' Freddie said 'Sounds good to me.'" With that, Fisk stepped to the plate and drilled a 1-0 fastball that was down and in. "I knew it had the distance and the height. I just wasn't sure it was going to stay fair," Fisk recalled. With a few waves of his arms into fair territory and the clang of the ball hitting the left field foul pole, the Red Sox won probably the most famous World Series game in baseball history. Fisk held the record for most games caught in a Red Sox uniform until 2006, when Jason Varitek broke the record. He won a Rawlings Gold Glove in 1972 when he was Rookie of the Year, and was a seven-time all-star. The left field foul pole is named after him. Carlton Fisk is shown here, posed in his most famous position at Fenway Park.

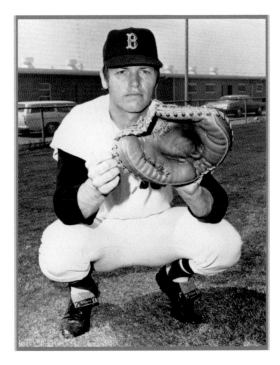

From the Red Sox Archives, *c.* 1975

*My dad arrived from Cuba a week before he threw that first pitch [at Game 1 of the 1975 World Series].
I hadn't seen my dad in 17 years. I pitched [the night he first arrived] against the California Angels
pitcher Ed Figueroa. I lost that game, and my dad was mad at me. Seventeen years is a long time not
to see your mother or father, it was hard. I didn't know if I would ever see them again. I used to call
him though. My friend had a phone over there, and I used to call him and tell him I was going to call
back at a certain time and somebody would go get my dad.*

*When I saw my mother and father, I cried. It was because of my mother that I played baseball, my
father really didn't want me to play. He played in the Negro Leagues in Cuba for 25 years, and they
didn't make any money in those days. He made like 50¢ a game. And they had to play three games
a day. So he wanted me to become a doctor and go to school. He was proud when I made the major
leagues though.*

*My parents lived with me for 16 months once they came over. Then my father passed away, and a
day and a half later, my mother died of a heart attack. I buried both of my parents on the same day.*

—Luis Tiant

Luis Tiant won many big games for the Red Sox; he pitched a three-hit win vs. Oakland in the
1975 American League Championship Series and shut out the Cincinnati Reds in Game 1 of the
World Series that year. He also pitched a two-hit shutout in 1978 vs. Toronto to force a one-game
playoff with the New York Yankees. He is pictured here with his father at Game 1 of the 1975
World Series.

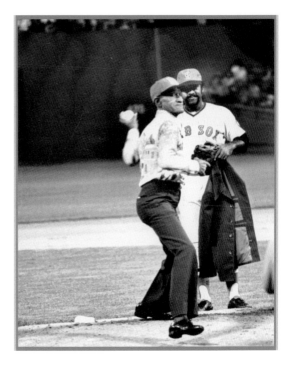

From the Red Sox Archives, 1975

You know, I grew up playing on winning teams. I came from the University of Southern California where we won three national titles in my three years. We won the Triple-A World Series in Pawtucket. And I played on some USA teams . . . and we won. So [playing on a winning team] was nothing new for me. I expected it, to tell you the truth. Wherever I went, we won. So I didn't feel any pressure in the pennant race. It was fun for me. I enjoy playing in those situations. I don't enjoy it when you're at the bottom looking up, like when you're in last place and you have no chance. Oh man, I hate that. That's not fun. But I really enjoyed playing the Yankees in Yankee Stadium with everything on the line. That's what makes it fun for an athlete, at least it did for me.

The wall was made out of tin in those days. But below it was concrete, cement about 12 feet up. And then you had the scoreboard in between, which is metal or tin. [They padded it] after the '75 series when I ran into it. Ken Griffey hit a ball into left center, and I hit that concrete. Everybody thought I was knocked out, but I wasn't . . . but I had no feeling from my waist down. So I thought I broke my back, so I didn't move until I started to get some tingling and some sensation down my leg. I started to feel my toes, and that's when I got up.

—Fred Lynn

Fred Lynn was both the American League Rookie of the Year and MVP in 1975 and won four Rawlings Gold Glove awards. He is shown here accepting his 1975 Gold Glove trophy. He played for the Red Sox from 1974 to 1981.

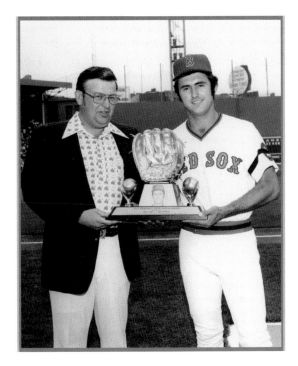

From the Red Sox Archives, 1976

[My first year] we started the season on the road, but my second start happened to be opening day at home. It was probably one of my fondest memories, looking back; we were playing the Texas Rangers, and I went into the 10th inning, they took me out in the 10th inning with two outs. It was my first appearance, so when I walked off they gave me a standing ovation, which is how it is here, but at the time, I had never seen anything like that—so it was a great moment.

I had never been in a winning situation [before], the three years I was in Cleveland we were lucky to be .500. So to play for the Red Sox like that and we had such a great team that we sort of ran off with it. We stumbled, for a lot of reasons, one of them was [Rick] Burleson being out, but anyway we stumbled, but I remember the way it ended, not necessarily the last game but the last two weeks we played like hell just to get a tie with the Yankees. I think we won our last eight games, that's what I remember. As far as the playoff game [1978], it's anybody's game, it just wasn't in the stars—obviously.

—Dennis Eckersley

Dennis Eckersley won 20 games in 1978 and was on the American League all-star team in 1982. He played with the Red Sox from 1978 to 1984 and again in 1998.

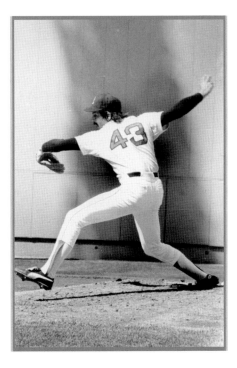

Jerry Buckley photograph, from the Red Sox
Archives, c. 1979–1983

One of the most successful lefties in Red Sox history, Bruce Hurst had six consecutive Red Sox seasons with 10 or more wins and 115 or more strikeouts from 1983 to 1988. The all-star pitcher thrived in pressure situations. His performance during the 1986 postseason was outstanding. He went 1-0 with a 2.40 ERA in 15 innings in the 1986 American League Championship Series against the California Angels. In the 1986 World Series, Hurst started three games and went 2-0 with a 1.96 ERA over 23 innings pitched. Hurst played with the Red Sox from 1980 through 1988. He was an all-star in 1987 and still holds the Red Sox strikeout record (190) for a left-handed pitcher. He was inducted into the Red Sox Hall of Fame in 2004.

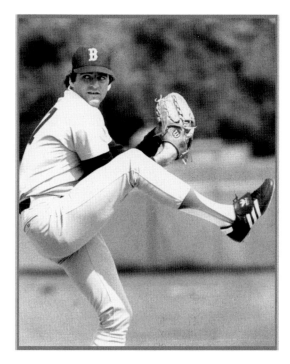

From the Red Sox Archives, c. 1982–1986

1975 was my first year, and you had two outstanding players playing for one ball club and both in the running for MVP and Rookie of the Year. Of course, we both couldn't accomplish that feat. I broke my hand in Detroit with 10 days to go in the season and wasn't able to play in the postseason. I took my cast off, it was on and I went in and cut it off because I wanted to play in the World Series. But that was just me. Some guys can play with pain, and some guys can't play with pain. And I was one of the guys that thought I could play and help the ball club, and so I went in and cut the cast off. But I think what stopped the Red Sox was that I was still on the disabled list. If I was on the disabled list, I had to stay there a certain number of days, and I couldn't come off even though I cut the cast off.

1978 was the year that I never imagined, of course, 40-plus home runs, 200-plus hits, 400 total bases. I just think when you are in a groove, you see everything and you try to make solid contact. That's one of the seasons that every player wants to have and win the MVP. It was a great year.

—Jim Rice

Jim Rice played his entire 16-year career with the Red Sox, from 1974 to 1989. He was the American League MVP in 1978, was an eight-time all-star, hit 20 or more home runs 11 times, and had 100-plus RBIs eight times.

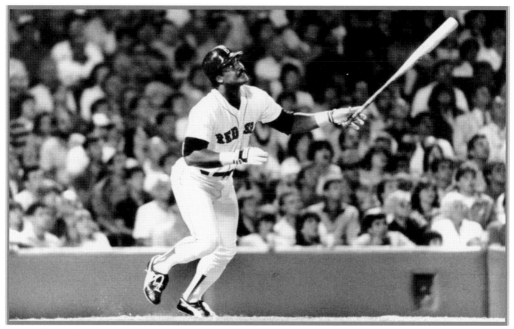

From the Red Sox Archives, c. 1975–1986

Bob "Steamer" Stanley proved to be one of the most versatile pitchers in Red Sox history. He was a fan favorite during his 13 years with the Red Sox. He both started and relieved in 1977, his rookie year, and ended up appearing in 41 games. In 1978, he went 15-2 to garner the team's all-time highest single-season winning percentage at .882. Stanley also holds the American League record with 168.1 relief innings in 1982. He is also the all-time Red Sox leader with 85 relief wins, 637 appearances, and 132 saves. He was a two-time all-star and set a team record with 33 saves in 1983 (tied for third best in 2006). He is shown here posing with a group of kids before a game at Fenway Park.

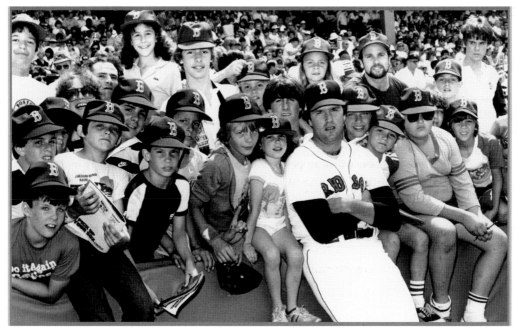

From the Red Sox Archives, *c.* 1977–1989

Upon joining the Red Sox as a rookie third baseman in 1982, Wade Boggs set a then rookie record with a .349 batting average (118-338) in 104 games. He won his first of five batting titles with a .361 batting average in 1983 and then four consecutive titles from 1985 through 1988. Boggs was voted to eight consecutive All-Star Games and is the only player in major-league history to collect 200 hits and 100 runs in seven consecutive seasons. His .338 Red Sox career batting average ranks second on the club's all-time list, below only Ted Williams (.344). Boggs leads all Red Sox third baseman for most games (1,165), assists (2,956), and double plays (299). He also ranks on the Red Sox all-time lists for on-base percentage (third, .428), doubles (fourth, 422), walks (fourth, 1,004), hits (fifth, 2,098), total bases (sixth, 2,869), runs (sixth, 1,067), extra-base hits (sixth, 554), at bats (seventh, 6,213), and games (seventh, 1,625).

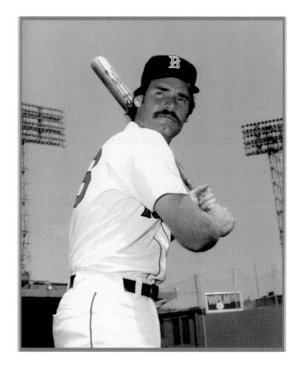

From the Red Sox Archives, *c.* 1983

Bruce [Hurst] was a great teammate, and we had a personal relationship, as I did with Roger [Clemens] and Al Nipper. I came up with Al Nipper; Al and I played together in Single A, Double A, Triple A baseball and also in the major leagues, so you know I have more time in the game with Al Nipper. But I became very, very close to Roger and Bruce as well; none of them were as animated as I was, but they all had individual personalities. Lefty [Bruce Hurst] could pitch! Bruce and I had a little thing we would do before every ball game that he would pitch. I would warm Bruce up in the outfield before each and every one of his starts. I would actually get down, and he would throw some curve balls, throw some changeups, and I would compliment him, and I would say, "Lefty, you're going to be on tonight." The three games that I remember the most that Roger, Bruce, and I pitched, we were in New York and we swept the series there in 1986, and that pretty much put us in the driver's seat to be fortunate enough to go to the playoffs and after that the World Series. Bruce was a very, very good pitcher, good overhand curve ball, good straight changeup, hit his spots very well, very smart on the mound. It was an outstanding three pitchers to play with in my career, and we became real close to each other and we depended on each other and we all pulled for each other—just a great thing—just a great situation for me to be in. It was probably the most special part of my career, playing with those three guys.

—Oil Can Boyd

This photograph shows three great pitchers sharing a laugh: from left to right, Bruce Hurst, Oil Can Boyd, and Roger Clemens.

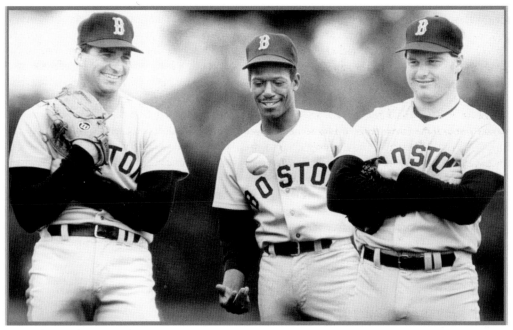

From the Red Sox Archives, *c.* 1986–1988

I think all great plays are always anticipated, [players are] always envisioning in their mind before every pitch, that's why you see shortstops make great plays, infielders make great plays, you have to anticipate the ball being hit in a certain area. I was actually, before that pitch [in the 11th inning of Game 6 of the 1975 World Series] . . . thinking if the ball is hit in the gap . . . I've got to go into the stands. Of course, I didn't end up doing that, but that's what went through my mind, and then when the ball was hit, I was actually prepared for it. It wasn't the best catch I ever made, but it was the most important catch I ever made. Usually when a left-hander hits the ball to right field, the ball hooks a little toward the right field line, and when Joe Morgan hit this ball, I turned to my left and started running back at an angle, anticipating the ball hooking a little bit or curving toward the line. Well, as I get back, the ball was not curving at all but staying straight. So I actually caught the ball behind me, it was behind my head. Now, if you ever play catch with somebody, turn sideways and have them throw it on the other side of your head and try to catch it, You lose it for about three or four feet, and that's what happened in that play. So no one was happier than me to feel that ball go in my glove because I had lost it for that certain amount of time there.

—Dwight Evans

Dwight Evans was a three-time all-star and eight-time Rawlings Gold Glove winner. He played with the Red Sox from 1972 through 1990. Evans's game-saving catch came in the 11th inning of Game 6 of the 1975 World Series when he robbed Joe Morgan of a possible three-run home run.

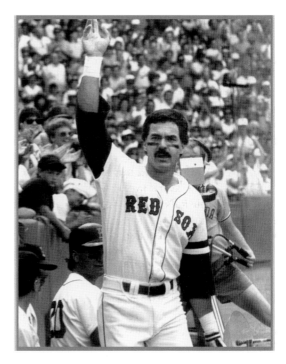

Bill Belknap photograph, *Boston Herald*,
from the Red Sox Archives, *c.* 1990

AUTOGRAPHS

AUTOGRAPHS

AUTOGRAPHS

AUTOGRAPHS

Arcadia Publishing is the leading local history publisher in the United States. With more than 3,000 titles in print and hundreds of new titles released every year, Arcadia has extensive specialized experience chronicling the history of communities and celebrating America's hidden stories, bringing to life people, places, and events from the past. To discover the history of other communities across the nation, please visit:

www.arcadiapublishing.com

Customized search tools allow you to find regional history books about the town where you grew up, the cities where your friends and relatives live, the town where your parents met, or even that retirement spot you've been dreaming of. The Arcadia Web site also provides history lovers with exclusive deals, advanced notice of new titles, e-mail alerts of author events, and much more.